Best-Loved Paintings

THE BLUE BOY

❧

PINKIE

Copyright 1963
Henry E. Huntington Library and Art Gallery
San Marino, California
Printed in Singapore
Revised edition 1998

❧

On the cover:
Sir Thomas Lawrence (1769-1830),
Sarah Barrett Moulton: *Pinkie*, (1794), detail
Oil on canvas: 57 1/2 in. x 39 1/4 in.

Thomas Gainsborough (1727-1788),
The Blue Boy (about 1770), detail
Oil on canvas. 70 in. x 48 in.

All paintings are in the Huntington collections unless otherwise indicated.

Wark, Robert R.
[Gainsborough's the Blue boy]
The Blue boy and Pinkie / by Robert R. Wark. — 1st Hardcover ed.
p. cm — (Best-loved paintings)
Originally published in 1963 and 1966 respectively.
ISBN 0-87328-170-5
1. Gainsborough, Thomas, 1727–1788. Blue boy. 2. Gainsborough,
Thomas, Sir, 1727–1788—Criticism and interpretation.
3. Lawrence, Thomas, Sir, 1769–1830. Pinkie. 4. Lawrence, Thomas, Sir.
1769–1830—Criticism and interpretation. 5. Henry E. Huntington Library
and Art Gallery. I. Wark, Robert R. Pinkie
II. Title. III. Series.
ND1329.G34A63 1998 97-33098
759.2—dc21 CIP

Best-Loved Paintings

THE BLUE BOY

✣

PINKIE

Robert R. Wark

The Huntington Library ✣ *San Marino, California*

Table of Contents

by Robyn Asleson

❧ List of Color Plates

 Introduction

❧ Ever since the arrival of *Pinkie* in the Huntington collection the painting has been closely linked with *The Blue Boy;* this association is understandable, for the paintings form in many respects a natural pair. And yet the differences are far more imposing and fundamental than the similarities. *The Blue Boy* is a magnificent act of homage on Gainsborough's part to the artist he admired above all others, the seventeenth-century portraitist Van Dyck. Gainsborough painted it apparently for his own pleasure, unimpeded by the restrictions that would normally hedge about a regular portrait commission. The measure of Lawrence's achievement in *Pinkie* is found precisely in the converse of this situation. There is nothing in the record to suggest that from his point of view the painting began as anything more than a routine portrait commission, involving a sitter of no particular importance, with whom he had no personal connection. Possibly the most remarkable thing about the painting is that from these distinctly unexceptional circumstances Lawrence should produce such a vital and fresh portrait that has rightly taken its place in the popular estimation as embodying the very spirit of English childhood.

1

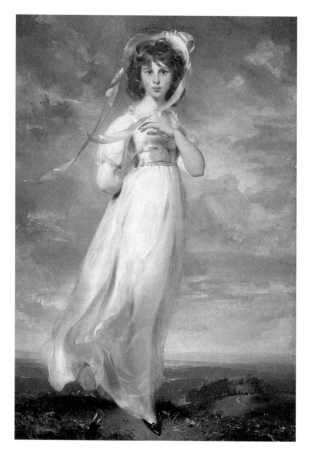

PLATE I
Sir Thomas Lawrence (1769–1830), Sarah Barrett Moulton: *Pinkie* (1794)

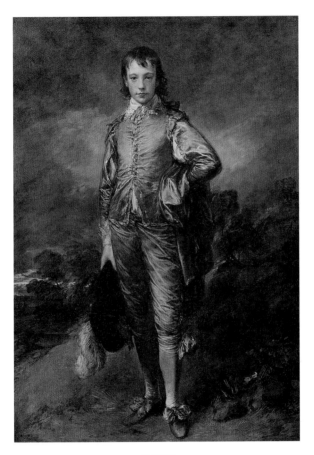

PLATE II
Thomas Gainsborough (1727–1788), *The Blue Boy* (about 1770)

❧ Gainsborough's *The Blue Boy*

❦ No other painting by a British artist enjoys the popularity of *The Blue Boy*. And it deserves its fame, for the picture is one of the most remarkable productions of a painter who is in many respects the best that England has produced. Yet this great popularity is a doubtful asset. Few paintings have been more frequently reproduced than *The Blue Boy*. It has appeared in every conceivable form: on playing cards, candy-box covers, cocktail napkins, porcelain plates, high-ball glasses, and ashtrays. The same familiar figure may emerge as a statuette, as a needlepoint picture, or dimly in the background of a clothier's advertisement telling the public to take a hint from Thomas Gainsborough and wear blue. The result of this activity is that for most people the painting is so entangled with irrelevant associations that it is almost impossible to have any direct reaction to it as a work of art. In a word, the image is hackneyed.

The original painting itself is certainly the most potent antidote to the dulling effect of innumerable copies. Anyone in the presence of the original is immediately struck by its power and assurance, so different from the cloying sentimentality that frequently hangs about the reproductions. The painting, like most fine works of art, appeals in different ways. Many visitors enjoy it simply for what it

represents: a handsome young man in a handsome costume. Others find pleasure in Gainsborough's performance as a painter: the vigorous brushwork that builds the firmly modeled figure; the skillful way in which the cool blue of the costume is given vitality by being placed against the stormy sky. Still others (with a leaning toward the history of art) will be impressed by the unusual qualities of the painting when seen in relation to other portraits by Gainsborough and his contemporaries; for there can be little doubt that this was no routine portrait commission but a picture the artist painted with special enthusiasm. From whatever point of view we approach the painting, it is certainly one of the most memorable of Gainsborough's achievements, well entitled to a place of honor in the select company of major British portraits.

Stories and anecdotes envelop a work of art much as ivy does a building. They often add to the charm but at the same time may obscure and even damage what they are intended to enhance. A painting as famous as *The Blue Boy* naturally has a great many stories clinging about it. These involve almost every aspect of the picture: the identity of the young man represented; the place of the painting within Gainsborough's career; the special circumstances that

governed the creation of the portrait; and the history of what has happened to it since the eighteenth century. Many of these stories are true, but others are only half true or false. The latter, by building a sham environment around the work of art, get in the way of our proper understanding and enjoyment of it. The account that follows is an attempt to present the evidence and set the record straight, with the hope that the way may thus be cleared for a more sympathetic and enlightened approach to the painting itself.

Who Was the Blue Boy?

❧ In spite of the great reputation *The Blue Boy* has enjoyed during the last century and a half, the picture does not appear to have attracted much attention during Gainsborough's lifetime. There are no absolutely certain contemporary references that answer any of the basic questions about it. The evidence concerning the identity of the sitter dates from twenty years after Gainsborough's death, but nevertheless it is reasonably convincing. In 1808 a volume appeared by Edward Edwards entitled *Anecdotes of Painters. The Blue Boy* is mentioned in the book, and a footnote is added stating: "This was the portrait of a Master Bruttall, whose father was then a very considerable ironmonger, in Greek-street, Soho." Edwards was an associate of the Royal Academy. He was only eleven years younger than Gainsborough, with whom he was probably acquainted; certainly he had opportunity to meet people who knew Gainsborough well. His comments, accordingly, have the authority of a contemporary source. Edwards died in December 1806 and his book was seen through the press by someone else, but there is no evidence that the editors tampered with the text.

Edwards has misspelled the name, but he is clearly referring to a certain Jonathan Buttall, who, like his father, was an ironmonger (or hardware merchant) in Greek Street in the Soho area of London. We do not know much about Buttall, aside from the fact that he was a personal friend of Gainsborough and (according to the artist's biographer William Whitley) one of the very select group that the painter requested should attend his funeral. The Buttalls owned property in Ipswich, where Gainsborough had lived as a young man, and it is possible accordingly that the friendship was of long standing. Buttall ran into financial difficulties in the 1790s, and his possessions were sold at auction on Thursday, December 15, 1796. The sale was attended by the artist Joseph Farington, who noted in his diary: "Gainsboroughs picture of a Boy in a Blue Vandyke dress sold for 35 guineas." This is the earliest explicit reference to the painting so far located. But evidently Farington did not know that the sitter was Jonathan Buttall himself. Buttall died late in 1805 and was buried on December 6 at St. Anne Soho. According to the "Account of Burials" for the church, he was fifty-three at the time of his death.

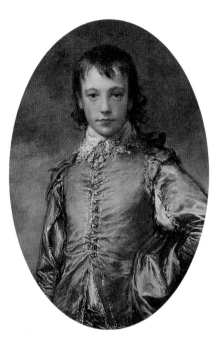

PLATE III *The Blue Boy*, detail

❧ The question of when Gainsborough painted *The Blue Boy* is more elusive than the identity of the sitter. On general stylistic grounds it is clear that the painting must date from the middle phase of the artist's career, sometime after the mid–1760s but before the 1780s. Gainsborough's early style, represented in the Huntington collection by *A Lady with a Spaniel* (Plate IV), has great charm but lacks the easy assurance and aristocratic elegance of *The Blue Boy*. Likewise his late work, of which the Huntington gallery's *Lady Petre* (Plate V) is a characteristic example, has a diaphanous and filmy quality arising from economic and fluid brushwork, all of which is very different from the comparatively thickly applied paint and solidly modeled form in *The Blue Boy*. At the time Gainsborough executed the painting his art was balanced between the two extreme positions. At this stage of his career he was resident in Bath, the fashionable resort town in the west of England. The change from his early to his late style was to a great extent dictated by the changing demands of his patrons. What pleased and suited the country gentry around Ipswich (where he worked as a young artist) would not satisfy the world of fashion at Bath and London. But the change was also prompted by

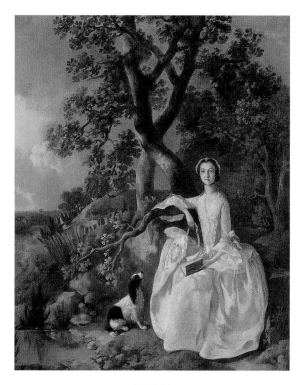

PLATE IV
Thomas Gainsborough:
A Lady with a Spaniel (about 1750)

An example of Gainsborough's early style.

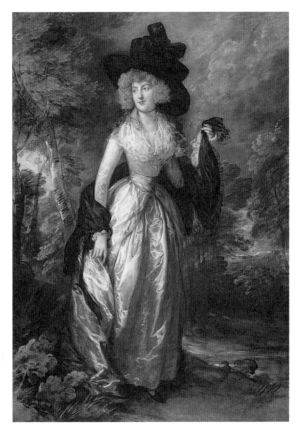

PLATE V
Thomas Gainsborough: *Lady Petre* (1788)
A characteristic example of Gainsborough's late work.

Gainsborough's contact with the portraits of the seventeenth-century painter Sir Anthony Van Dyck (Plate VI). Gainsborough had unbounded admiration for the work of Van Dyck, and the younger man found a congenial model in the formula for portraying the English aristocracy that had been perfected by his predecessor over a century earlier. It was during Gainsborough's residence in Bath that the influence of Van Dyck was paramount, primarily in the format he adopted for his portraits and in the sense of dignity and aristocratic grace he was able to suggest in his sitters. Nevertheless it is unusual, at any stage of his career, to find the painter modeling himself so deliberately on Van Dyck as he does in *The Blue Boy*; even the costume, as well as the format and the pose, are derived from the seventeenth-century master. It is also rare at any time for Gainsborough to apply his paint so densely.

So the internal stylistic evidence presented by Gainsborough's own work does not enable us to go very far in suggesting when he painted *The Blue Boy*— the picture is too unusual to be easily pigeonholed. It may be worth noting, however, that Gainsborough uses again what certainly appears to be the

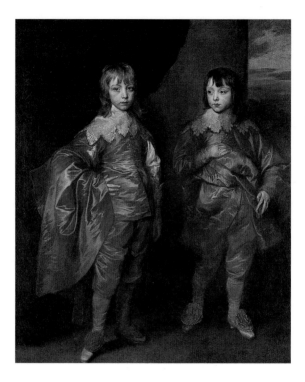

PLATE VI
Sir Anthony Van Dyck (1599–1641):
George and Francis Villiers
The Royal Collection, Windsor Castle

This painting illustrates the extent to which *The Blue Boy* reflects the work of Van Dyck in the pose and costume of the figure.

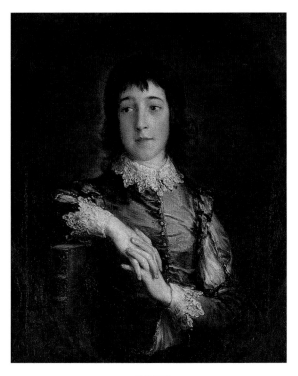

PLATE VII
Thomas Gainsborough:
The Honorable Edward Bouverie
Collection, Earl of Radnor

The costume worn by the sitter is apparently the same
as that worn by the Blue Boy.

same Van Dyck costume in two other portraits that can be firmly dated. The similarities (especially in the cut of the sleeve and shoulder) are too close to be accidental. One of these, The Honorable Edward Bouverie (Plate VII), is inscribed 1773 and was paid for in September 1774. The other, Paul Cobb Methuen, was paid for in 1776. One is inclined to assume, on examining the dress in the three portraits, that Gainsborough must have actually had a Van Dyck costume in his studio, available for sitters who (in accordance with a curious fashion of the day) wanted their portraits painted in "fancy dress." This suggestion does not help much in dating The Blue Boy, although Gainsborough was at least using the costume in his portraits of the early 1770s. The theory that Gainsborough kept a Van Dyck costume in his studio is given considerable support by some of his portraits of ladies in fancy dress from the 1770s (notably the Hon. Mrs. Graham, the Hon. Frances Duncombe, and Lady Margaret Fordyce) which utilize what is unquestionably the same woman's costume and hat, although the colors change.

A more specific point in the matter of dating is that Gainsborough did undoubtedly exhibit a

portrait of a man in Van Dyck dress at the Royal Academy in 1770. For this we have the evidence of an academician, Mary Moser, who when describing the exhibition in a letter to Henry Fuseli said, among other things, "Gainsborough [is] beyond himself in a portrait of a gentleman in a Vandyke habit." It is unfortunate that Mary was not a little more explicit. The catalogue of the Royal Academy exhibition of 1770 indicates that Gainsborough showed four male portraits that year, two full-lengths and two at three-quarters. One of the latter has been identified as a portrait of David Garrick, the actor; one of the former (No. 85) is particularized in the catalogue as a portrait of a young gentleman. If Mary's comment referred to No. 85, then the painting was very probably *The Blue Boy*, as we have no record of any other full-length portrait of a boy in a Van Dyck costume that could have been painted by Gainsborough prior to 1770. But unfortunately Mary does not say whether or not it was a "young" man she saw, or whether the portrait was full length.

There is, however, one thirdhand, rather flimsy bit of evidence from a much later date supporting the suggestion that it was indeed *The Blue Boy*

that so impressed Mary Moser at the exhibition of 1770. J. T. Smith, the highly entertaining biographer of the sculptor Joseph Nollekens, records in *A Book for a Rainy Day* that on the third of November 1832, he was visited by his friend, the artist John Taylor, then in his ninety-third year. The conversation turned to Gainsborough. Taylor remarked: "'Oh! I remember him; he was an odd man at times. I recollect my master Hayman coming home after he had been to an exhibition, and saying what an extraordinary picture Gainsborough had painted of the Blue Boy; it is as fine as Van Dyke.'" Smith then inquired who the Blue Boy was. "'Why, he was an ironmonger, but why so called I don't know. He lived at the corner of Greek and King Streets, Soho; an immensely rich man.'" So Taylor also thought the Blue Boy was Jonathan Buttall. More important, however, is his recollection of Hayman's comment. Francis Hayman died in 1776. As far as one can gather from the exhibition records, the only full-length of a boy by Gainsborough that he would have seen was No. 85 in the Royal Academy exhibition of 1770. Although thirdhand and remote in time, the statement strongly supports the suggestion that *The Blue Boy* was in the 1770 exhibition.

Of course, if we accept the identification of the boy as Jonathan Buttall, then his lifespan offers further evidence concerning the date of the painting. If Buttall was fifty-three at his death late in 1805, then he was born in 1752 or the last days of 1751. It is notoriously difficult to determine the age of a sitter from his appearance in a portrait, but there surely will be general agreement that the Blue Boy is—at the oldest—in his teens. If the sitter is Jonathan Buttall, then a date for the painting after 1770 would seem most improbable.

❧ Why did Gainsborough Paint
 The Blue Boy?

❦ One particularly attractive and persistent story concerning the origin of the painting suggests that Gainsborough undertook the picture to prove that his great contemporary rival, Sir Joshua Reynolds, was wrong when he stated that a cool color, such as blue, should never be the dominant area in a painting. The story fits so well with the very positive character of the painting and with what we know of the personalities of the two artists that one wishes it might be true. But unfortunately the only recorded statement by Reynolds that could serve as a basis for the story is included in one of his discourses to the Royal Academy delivered in 1778, well after the time when *The Blue Boy* must have been painted. Furthermore, the anecdote is not mentioned by any of Gainsborough's early biographers, several of whom knew him personally and would surely not have neglected such a fascinating and revealing episode if it had any foundation in fact. The story appears to have emerged in print first in John Young's *A Catalogue of the Pictures at Grosvenor House* (1821): "This Picture was painted in consequence of a dispute between Gainsborough, Sir Joshua Reynolds, and several other Artists. The former having asserted that he thought the predominant colour in a Picture ought to be blue; the others were of the opinion that it was not possible

to produce a fine picture on such a principle; and the Artist in consequence painted this Portrait as an illustration of his opinion. It was considered that he had proved his assertion; and his performance having excited great attention, and become a general theme of praise with the Artists of that day, tended much to enhance the reputation he had already acquired." The anecdote grew with appropriate elaboration as time went on.

There is, however, another story concerning the origin of the painting that comes from an early and ascertainable source. This account was printed in the *European Magazine* for August 1798, and the author has been identified by Whitley (in his *Artists and Their Friends*) as William Seward, a friend of Reynolds and Samuel Johnson, well acquainted with the cultural life of London during the late eighteenth century. The notice reads: "Mr. Gainsborough. One of the finest portraits that this great artist ever painted, and which might be put upon a par with any portrait that was ever executed, is that of a boy in a blue Vandyke dress, and which is now in the possession of a tradesman in Greek-street. Gainsborough had seen a sketch of a boy by Titian for the first time; and, having found a model that pleased him, he set to work with all the enthusiasm of his genius. 'I am proud,' said he, 'of being of the same profession with

Titian, and was resolved to attempt something like him.' The famous large picture of Vandyke at Wilton was in general the model to which Gainsborough pointed, and he had arrived at a great facility in imitating that master."

The passage is puzzling as it leaves the reader uncertain about whether Seward thought the real inspiration for the picture was the work of Titian or of Van Dyck. Actually there is very little that is specifically Titianesque about *The Blue Boy*. The paint application, especially on the left sleeve, does remind one of the great Venetian, but all the references are emphatically to Van Dyck in pose, format, and costume (Plate VI). There is, however, something very attractive and persuasive in Seward's suggestion (as in the anecdote about the dispute with Reynolds) that the painting was executed in answer to some sort of artistic challenge rather than simply as a regular commission. And there is in fact some specific evidence, not available to these early commentators, that strongly confirms the suggestion that the painting was not undertaken as a normal portrait.

In 1939 an x-ray photograph revealed at least the beginning of another portrait of an older man beneath that of *The Blue Boy* (Plates VIII and IX). It is clear from the position of the head of the older

PLATE VIII
X-ray detail of *The Blue Boy* showing the neck and lower portion of the face of an older man above the head of the Blue Boy.

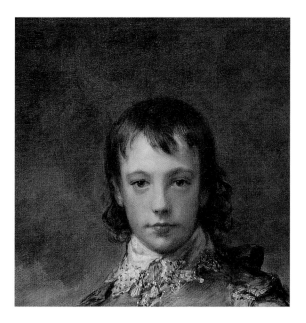

PLATE IX
The Blue Boy, detail corresponding to the x-ray detail in Plate VIII.

man that Gainsborough had planned the canvas as a normal full-length, which he subsequently cut down when he painted *The Blue Boy*. We know nothing about this earlier painting—who was represented, or why Gainsborough never completed the work. But these problems are (as far as our discussion is concerned) less significant than the fact that *The Blue Boy* is painted on a piece of canvas that Gainsborough had used before. It is unlikely that a portrait painter beginning a new commission, with the sitter presumably in the studio, would pick up a used piece of canvas. The circumstance of the used, cut-down canvas strongly suggests that the painting was undertaken primarily for the artist's own satisfaction.

It is most improbable that we will ever now find out definitely whether or not *The Blue Boy* was painted to meet a special challenge. But from the evidence at hand a tentative deduction is at least possible: Gainsborough (in answer to the demands of his patrons for portraits in fancy dress) had a Van Dyck costume made to keep in his studio. The artist's young friend, Jonathan Buttall, modeled the costume. (He may have even continued to act as the studio "sit-in" for the other portraits, all somewhat later, using the same dress.) Gainsborough, struck by the model's appearance, picked up a discarded

canvas and tried an essay in the style of Van Dyck. If this line of reasoning is correct, then it is clear we should regard *The Blue Boy* as distinctly apart from the artist's normal commissioned portraits. Rather it is a *jeu d'esprit,* Gainsborough's homage to his mentor, an artist whom he admired above all others. Thus the picture should be classed along with Gainsborough's landscapes and so-called "fancy pictures" as something painted for his own pleasure.

It is interesting in this connection that in one of the very earliest comments on *The Blue Boy,* the painting's peculiar power is attributed to the direct influence of Van Dyck. In 1798, William Jackson, in an essay on Gainsborough included in *The Four Ages,* criticizes the artist's "thin washy colouring" and "hatching style of pencilling," but then goes on to say, with specific reference to *The Blue Boy,* "when, from accident or choice, he painted in the manly substantial style of Vandyke, he was very little, if at all, his inferior." Jackson's remark is of special interest because he was a personal friend of Gainsborough. Yet it would be misleading to give the impression that *The Blue Boy* owes all its distinction to the earlier artist. The references to Van Dyck, though emphatic and unmistakable, in no way dim the strength of Gainsborough's own personality, which shines through with a warmth,

energy, and directness that creates a very different total impression from the comparatively cool aristocratic detachment characteristic of Van Dyck's English work.

❧ A conservation survey of British paintings at the Huntington in 1995 led to remarkable discoveries about *The Blue Boy*. The technical analysis, funded by the Getty Grant Program, included microscopic, infrared, and ultraviolet examination, as well as x-radiography. X-rays pass through solid substances but are obstructed by materials such as lead compounds. The lead content in white paint appears opaque when x-rayed, thus revealing layers of pigment that are often invisible to the unaided eye.

The recent x-ray of the *The Blue Boy* revealed the presence of a dog—apparently an English water spaniel—standing at Buttall's side (Plate X). Gainsborough evidently felt the need to revise his initial conception, and he eliminated the dog from his final composition. Perhaps it detracted from his Grand Manner presentation of the young hardware merchant dressed and posed in an aristocratic style reminiscent of Van Dyck.

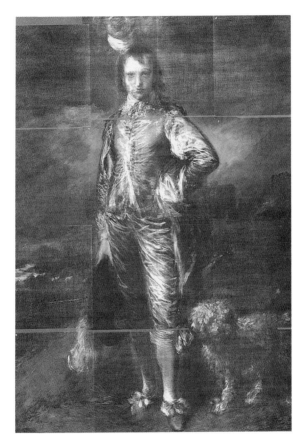

PLATE X

The complete x-ray of *The Blue Boy* reveals a dog that Gainsborough
eliminated from the final painting.

❧ The History of the Painting

❧ The earliest explicit mention of *The Blue Boy* thus far located is in 1796, eight years after Gainsborough's death. On December 15, 1796 (as already mentioned) Joseph Farington, after attending a sale of the possessions of Jonathan Buttall, noted that the picture was sold for thirty-five guineas. Within two years the fame of *The Blue Boy* seems to have been well established. In 1798, William Jackson, in the same essay on Gainsborough referred to earlier, states: "Perhaps, his best portrait is that known among the painters by the name of the Blue-boy—it was in the possession of Mr. Buttall, near Newport-market." It is Farington once again, in another entry in his diary, dated May 25, 1802, who supplies some further history of the picture: "I painted till four o'clock & then went to Nesbitts sale in Grafton-street, where I met Hoppner who had purchased the Boy in Blue dress by Gainsborough which was Buthalls [sic] for 65 guineas. At Buthalls sale it was sold for 35 to Mr. Nesbitt." John Hoppner, himself a distinguished portraitist, had the painting for several years; at least Edward Edwards speaks of it in 1806 as still in his possession. But sometime before his death in 1810 he had disposed of it to his friend and patron, Robert, 2nd Earl Grosvenor,

later 1st Marquis of Westminster. The portrait remained in the Westminster collection through the nineteenth century and until it was acquired in 1921 by Henry E. Huntington from Hugh, 2nd Duke of Westminster.

During the nineteenth century the fame of the painting became ever more widely and firmly established through its appearances at national and international exhibitions: at the British Institution in 1814 and 1834; at the Manchester Exhibition of 1857; at the International Exhibition, London, in 1862 and the Royal Academy in 1870; at the Grosvenor Gallery in 1885 and again at the Royal Academy in 1896; and at the Old English Masters Exhibition, Berlin, and the Franco-British Exhibition, London, both during 1908. By the early twentieth century *The Blue Boy* had become one of the most familiar and popular of all paintings. And this fame was even further augmented by the widely publicized circumstances surrounding the purchase of the picture by Mr. Huntington.

By 1921 Mr. Huntington was already well started on the formation of his great collection of British portraits. Several paintings of distinction, including such masterpieces as Gainsborough's Lord and Lady Ligonier, had been in his possession for a decade,

and he had purchased prints of Blue Boy in 1901, 1903, and 1909. Although the story attributed to the art dealer Joseph Duveen to the effect that Mr. Huntington first encountered a reproduction of *The Blue Boy* on the *Aquitania* in the summer of 1921 is fallacious, it seems likely that Duveen, who accompanied Mr. and Mrs. Huntington on the voyage, knowing very well of their interest in British painting and knowing also that the Duke of Westminster at that time was inclined to part with some of his treasures, simply put two and two together. In any event, the sale was completed by an exchange of letters on October 7, 1921, between Mr. Huntington, then at Beauregard, near Versailles, and Duveen, then at his Paris office in the Place Vendôme.

Before the painting left England it was carefully cleaned and was exhibited at the National Gallery from January 4 until January 24, 1922. The cleaning was undertaken by William Holder, a London restorer, who had received many commissions to work on pictures in the National Gallery. The operation proceeded with the knowledge and support of Sir Charles Holmes, then Director of the National Gallery, and the Keeper, C. H. Collins Baker. The paint surface was found to be completely intact, and no retouchings were necessary.

But the color relationships within the painting were radically changed when the heavy discolored layer of varnish was removed.

Judging from the newspaper reports, the public reaction to the transformation in the appearance of the painting was mixed, although generally favorable. Everyone was impressed by the fresh and brilliant color and the change in the hue of the costume from a rather murky green to an azure blue. Writers for *The Times* (December 31, 1921), *The Queen* (January 14, 1922), and the *Evening Standard* (January 16) all felt the change restored the painting to something like the appearance it must have had in the artist's own day. But there were others, notably in the *Morning Post* (January 3), who felt that the removal of the old varnish deprived the painting of some of its fascination: "Aloofness that was half its charm has disappeared with the old varnish. The figure now asserts itself, seems to have come out in front of the frame, and the illusion of height has gone."

At the close of the London showing, Sir Charles Holmes wrote to Duveen: "I saw the last, for the time being anyhow, of *The Blue Boy* this afternoon at ten minutes past four, and feel bound to write these lines to thank you & Mr.

Huntington for the pleasure which the sight of it has given to more than 90,000 people during the last three weeks. It is, indeed, a most brilliant thing, outshining in its present condition all our English pictures at Trafalgar Square, and when the natural mellowing of the varnish during the next two or three years has taken place its perfections will be enhanced."

The painting left England by a slightly circuitous route, arriving in New York on February 7, 1922. In an unusually informative letter, Duveen outlined to Mr. Huntington the procedure followed. "One of our representatives who brought the picture over, tells me of an incident which I think will afford you much amusement. It appears that the Cunard Steamship Co. and the White Star Line have been for weeks angling for the shipment of the picture. Every time these two companies in London noticed any reference to the shipment of the Blue Boy, they either telephoned or called, anxious to have the honor of shipping it. I would like to say that attached to this honor was a small matter of the freight charge of one percent ad valorem . . . so their interest was not entirely disinterested. I can appreciate their disappointment when they learned, as they no doubt have done by

this time, that I had it sent over by hand from France by the French Steamship Line, who imposed no freight charge at all upon objects coming by hand, beyond the usual excess baggage rate, which in this case amounted to not more than $200 or $300. There was undoubtedly a tremendous amount of competition amongst the shipping companies, whose representatives were on the qui-vive to find out how the case was actually going, but our man took it from London early one morning in a covered motor van by a circuitous route to Southampton, arriving at that port about 11 o'clock at night after all the shipping companies were closed. The case was then placed upon the S.S. Antonia, which plies between Southampton and Havre, at which latter port it arrived early Friday morning, and after going through the usual customs formalities, it was safely placed aboard the La Savoie. All through these arrangements the whole matter was kept a dead secret, and no one but our representative was aware of the shipment of the picture. The only person who probably became aware of its identity was the purser of the La Savoie during the last two or three days of the trip."

After the painting's arrival in New York it was exhibited at the Duveen Galleries from February 14 to March 7. On March 1, Duveen again wrote to Mr. Huntington, indicating that he expected to leave New York by train on March 17, bringing the painting to California, together with Gainsborough's *Cottage Door* and Sir Joshua Reynolds's great portrait of Mrs. Siddons as the Tragic Muse, both of which Mr. Huntington also purchased from the Duke of Westminster. *The Blue Boy* actually arrived in San Marino on Tuesday, March 21, 1922.

The painting hung at first in the large drawing room of the Huntington residence. With the completion of the Main Gallery in 1934, it was moved to these more spacious quarters, where (with the exception of the years during World War II) it has remained ever since. The visitor now meets the painting surrounded by one of the most distinguished collections of major British portraits to be found under one roof. *The Blue Boy* looks across the gallery to his almost equally famous, younger compatriot *Pinkie*, painted by Sir Thomas Lawrence, while Reynolds's majestic portrait of Mrs. Siddons commands the space between. It is a compatible assembly in a sympathetic setting. Mr. Huntington's intention was to provide the paintings with an

environment which was at least reminiscent of that for which they were originally intended. Thus the portraits are enhanced by eighteenth-century furnishings in rooms whose proportions and decorations derive from eighteenth-century prototypes. The pictures also hang as the painters intended they should: above eye level, where they form part of the decorative ensemble of the rooms. Certainly it is in this way that British portraits of the Georgian period appear to the greatest advantage. Divorced from such a setting and displayed in an impersonal atmosphere, they lose a considerable portion of their appeal. And so *The Blue Boy*, although far removed physically from its original home, has found another in which the painting must recognize much that is congenial and familiar, and where its popularity continues unabated.

PLATE XI

The paintings *Pinkie* and *The Blue Boy* hang across from each other in the Huntington's Main Gallery.

✧ Thomas Gainsborough, 1727–1788

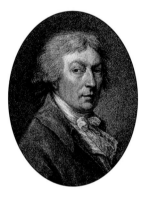

❧ Gainsborough was born in the small town of Sudbury in the eastern part of England. Little is known about his boyhood and early artistic training. While still in his teens, he spent several years in London working with the French artist Hubert Gravelot; he must also have come in contact at that time with the English painter Francis Hayman. Gainsborough returned to his native Suffolk in the late 1740s and soon settled at Ipswich. He there painted attractive small-scale, full-length portraits (such as the Huntington Gallery's *A Lady with a Spaniel*) and developed his interest in landscape, particularly under the influence of Dutch seventeenth-century artists.

In 1759 Gainsborough moved to the west of England to the resort town of Bath. His reputation, especially as a portraitist, grew very quickly. He began exhibiting his work in London in the early 1760s. By the time the Royal Academy was founded at the end of 1768, his fame was sufficiently well established that he was invited to become a member.

Gainsborough moved to London in 1774. Thenceforth until his death he was universally recognized as sharing with Sir Joshua Reynolds the position of foremost British portraitist of his day. Reynolds and Gainsborough were temperamentally

very different and had little direct contact with one another. Reynolds, an intellectual and deliberate man, was a close friend of Samuel Johnson, Edmund Burke, and Oliver Goldsmith. Gainsborough, more casual, but also more emotional and impulsive, sought in particular the companionship of musicians, numbering many distinguished composers and performers among his intimates. His splendid portrait of his close friend, the viola da gambist Karl Friedrich Abel, is one of the principal treasures of the Huntington gallery, a painting that is remarkable even in a collection that includes eleven of Gainsborough's finest canvases. It is characteristic of Gainsborough that to him Reynolds's work was largely an enigma; Gainsborough's best-known comment about his great contemporary was: "Damn the man, how various he is." Reynolds, on the other hand, understood with remarkable perception what Gainsborough was about, and Reynolds's "Fourteenth Discourse", delivered within a few months of his rival's death, remains one of the most astute and perceptive accounts of Gainsborough's art. Reynolds clearly saw even then, and was sufficiently magnanimous to state, that "If ever this nation should produce genius sufficient to acquire to us the honourable distinction of an English School, the name

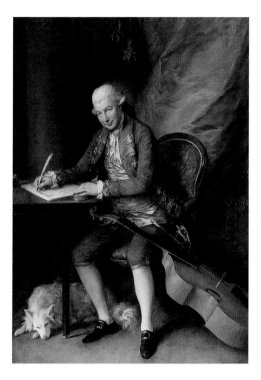

PLATE XII
Thomas Gainsborough: *Karl Friedrich Abel* (about 1777), detail.
Abel, a viola da gambist, was a close friend of Gainsborough.

of Gainsborough will be transmitted to posterity,
in the history of the Art, among the very first of that
rising name."

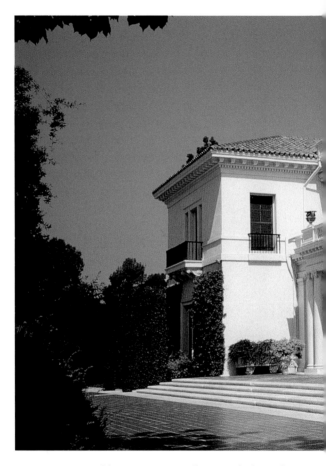

PLATE XIII Exterior of the Huntington Art Gallery, once the home of Henry and Arabella Huntington.

❧ Lawrence's *Pinkie*

❧ I BECOME every day more desirous to see my dear little Pinkey; but as I cannot gratify myself with the Original, I must beg the favor of You to have her picture drawn at full Length by one of the best Masters in an easy Careless attitude. As your Taste & Judg'ment cannot be excell'd, I leave her Dress to you.—You will therefore be so kind as to inform me by the first pacquet after you receive this, what the Amount will be, and I will get a Bill & send You as soon as possible.—I shall expect it out as soon as the paint is well dried & Seasoned—Let the frame be handsome & neat.*

This passage from a letter by an affectionate grandmother marks the origin of the painting now known the world over as *Pinkie*. The author of the letter was Judith Barrett, and she wrote from St. James', Jamaica, on November 16, 1793.

* This and other letters relating to the painting were first published by Philip Kelley and Ronald Hudson, "New Light on Sir Thomas Lawrence's *Pinkie*," *Huntington Library Quarterly* 28 (1965), 255–61.

🌱 Who Was Pinkie?

❧ The Barretts were a family of well-established landholders in Jamaica who had been associated with the island ever since the British conquest in 1655. During the following century and a half they had extended their holdings so that by the late eighteenth century they owned several important estates and were deeply involved in the sugar and rum production that were the controlling factors in the island's economy. The family fortunes were probably at their highest point in the 1790s.

Judith Barrett's daughter, Elizabeth, married a certain Charles Moulton in 1781; and Pinkie, Sarah Goodin Barrett Moulton, was their first child. She was born on one of the Barrett estates, Little River, St. James', Jamaica, on March 22, 1783. It was also on the Barrett estates, and particularly at a house called Cinnamon Hill, that Pinkie passed her early childhood and became (we may assume) a particular favorite with her grandmother. One can well imagine that Judith Barrett would have very mixed feelings when it was decided, probably in 1792, that Pinkie should accompany her two younger brothers, Edward and Samuel, to England, where the children were to be educated. The journey was a long one (six to eight weeks) and the times were uncertain (England and France were at war by 1793); clearly it

would be many years before Mrs. Barrett could expect to see her grandchildren again.

Mrs. Barrett had a niece, Elizabeth Barrett Williams, who lived near London on Richmond Hill. The children from Jamaica apparently did not stay with Mrs. Williams, but she was very much interested in their welfare, and it seems to have been through her that the doting Judith Barrett kept in touch with her grandchildren.

The letter asking for a portrait of Pinkie was received by Mrs. Williams on February 11, 1794. One does not particularly envy the lady the task appointed her. Commissioning a portrait for someone else is always a delicate and rather unsatisfactory business, and for an affectionate grandmother on the other side of the Atlantic, must have been especially so. Furthermore, aside from the facts that the portrait was to be full-length and exhibit Pinkie in "an easy careless attitude," all the details were left up to Mrs. Williams, whose "taste and judgment" were thus to be put to the test.

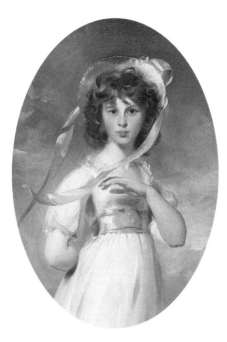

PLATE XIV *Pinkie,* detail

❧ Why did Lawrence Paint *Pinkie*?

❦ The first problem, of course, was to settle on an artist. Half a dozen years earlier the choice of "one of the best masters" would almost certainly have fallen on Reynolds or Gainsborough. But Gainsborough had died in 1788, and Reynolds in 1792. The two real giants of British portraiture were both gone, but somewhat too recently gone for the line of succession to be clearly visible. George Romney was still painting, but his abilities were noticeably on the decline. Gilbert Stuart, full of a promising London career in the 1780s, was back in America by 1793. Mrs. Williams was thus obliged to turn to the younger men, of whom the most prominent at the time were John Hoppner, William Beechey, and (much the youngest of the three) Thomas Lawrence. To us today, with the hindsight offered by over a century and a half of distance, there can be no doubt that Lawrence was the best man. But the relative merits of the three could not have been so clear then, although something did occur just as Mrs. Williams received Mrs. Barrett's letter that may well have been decisive in steering her to Lawrence.

Lawrence at the time was approaching his twenty-fifth birthday. He had been something of a child prodigy and had fortunately been able to

negotiate successfully the difficult transition from a boy wonder to an adult artist. His first great success came at the Royal Academy Exhibition of 1790, where he showed full-length portraits of Queen Charlotte and the popular actress Elizabeth Farren, later Countess of Derby. The latter painting in particular (now in the Metropolitan Museum) was a lively and scintillating achievement that did a great deal to establish the young portraitist's reputation. He was elected an associate of the Academy in the next year, and following the death of Reynolds he was offered the post of Painter in Ordinary to the King. On February 10, 1794 (the day before the arrival of Mrs. Barrett's letter), Lawrence was elected a full academician, squeezing out Hoppner by two votes. This success must have appeared to give him clear priority in the estimation of his professional colleagues, and it was timed perfectly to help Mrs. Williams with her choice.

We know nothing in detail about the actual commissioning of the portrait. One naturally wonders how much Mrs. Williams may have had to do with matters such as costume and pose. It would be particularly interesting to learn whether young Miss Moulton's nickname had anything to do with

the prominent use of pink; of course the name "Pinkie" as applied to Sarah probably had no reference to color. The word simply means small or diminutive, and likely referred to the little girl's size rather than her rosy cheeks. Nevertheless, it is both tempting and plausible to suppose that the nickname may have suggested the color.

The pose is also an interesting facet of the portrait. Mrs. Barrett asked for "an easy careless attitude," which certainly left a wide range of possibilities. But the actual pose chosen is a distinctive and unusual one. It is difficult to explain the position and gesture of the left arm and hand in relation to any particular action. The gesture is one Lawrence does not ever seem to have used again. Possibly Pinkie is caught in a little private dance that would have special meaning for her grandmother.

But whatever personal references may or may not be intended in such matters as the pose and color scheme, the total impact of the painting is distinctly in Lawrence's own idiom. As is often the case with works of art that enjoy great popularity and are extensively reproduced, the effect of the original painting on the spectator who sees it for the first time is almost startlingly vigorous and fresh. The reproductions and the context in which they

frequently occur create a saccharine air about the picture which is at complete variance with the painting itself. The little girl's face is in fact firmly set, with no indication of a smile. The rather severe expression is accentuated by the completely frontal presentation of the face—a position for the head which Lawrence used often and which tends to give added force and directness to the relation between the sitter and the spectator.

The color scheme of the picture is on the cool side: deep greens in the landscape, a turbulent sky, and the white of the dress relieved only by the pink of the sash and ribbons and of the little girl's complexion. The brisk, fresh quality of the painting is greatly enhanced by the breeze blowing the dress and ribbons, and by the low horizon line, which gives the impression that Pinkie is standing on the crest of a hill. Lawrence's early brush work is in complete harmony with the other expressive qualities of the picture. His paint application at this time has been aptly described as "waxy, crisp, and scintillating." There is a freedom and bravura in the way the paint goes on that accords perfectly with the mood of the portrait.

Recent x-rays of *Pinkie* (Plate XV) show that Lawrence extended a standard 50-inch, portrait-

size canvas approximately 8¼ inches at the bottom. The x-rays also indicate that Lawrence had not resolved the placement of Pinkie's left arm in his initial conception, nor the direction of her gaze. The most obvious change, however, is in the positioning of the ribbons of the hat, which were originally hanging straight down rather than decoratively blowing across the figure as in the final image. The alteration in the profile of the dress also adds a further sense of movement, enhancing the animation of the portrait.

The spirited, lively presentation of the figure employed by Lawrence follows a tradition established by Reynolds, who frequently animated a woman's portrait by depicting the sitter stepping forth across a lawn with a breeze rippling through her gown and hair. But aside from this general idea, Lawrence does not seem to have had any particular model in mind for *Pinkie*; the details of the pose and composition are his own. The painting, when it first appeared, would have seemed remarkably unhackneyed in all respects, a bright indication of the originality of the rising young star in British portraiture.

Work on the portrait must have proceeded without much delay after Mrs. Williams received

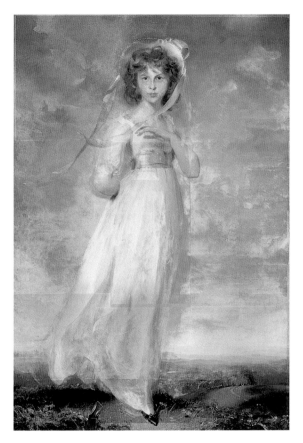

PLATE XV

This recent x-ray of *Pinkie* reveals differences in the placement of her left arm and the position of the ribbons from the final version.

her aunt's letter in February of 1794. On September 1 of that year Mrs. Williams sent a progress report to Mrs. Barrett. We do not have the actual letter, but it is clear from Mrs. Barrett's reply that the portrait must have been well along, although not finished:

> I am exceedingly obliged to You for the trouble You have taken about the picture and shall Consider myself indebted still farther, if You will be so obliging as to have it well packed when it is ready to be Ship'd. I observe what You say respecting the frame— and I think the best way will be, for You to send me an exact account of what I shall owe You after the frame and any other expences are paid for and I will remit You immediately the balance—for by sending 12 Guineas more it wou'd pay for the frame, but some other Expence might be incur'd, & I shou'd still have to remit to You again.

> I am really happy to hear that Pinkey is so well—I hope it may long Continue & that She may not bring back her cough by any imprudence.—Accept our best thanks for your continued Kindness to her.

Mrs. Williams wrote yet again to Mrs. Barrett on November 4, 1794, indicating that the final amount due on accounts connected with the frame and packing was £14. One is probably justified in assuming that the painting was completed by that date.

In spite of Mrs. Barrett's great eagerness to have the portrait, it was not sent at once to Jamaica. Apparently (although the exchange of letters gives out at this point) Lawrence, well aware of his success with the painting, asked if he might include it among the group he intended to send to the next exhibition at the Royal Academy in the spring of 1795. The Academy exhibition, it must be remembered, was then the great annual art event, as indeed it had been since its inception a quarter of a century earlier. It was in these exhibitions that the reputations of rising young artists were made and those of the established men constantly tested. Lawrence had won his laurels when elected a full academician early in 1794. But his extreme youth and the tendency of many critics to judge him in relation to his older but less highly lauded colleagues meant that he could never relax in these early years. Small wonder, accordingly, that he would request permission to retain for the exhibition such an unusual and remarkable painting as

Pinkie. From the point of view of the sitter and her family there would also be some satisfaction in seeing the portrait so highly regarded. And so it was that the picture remained in England to make its appearance as Number 75, *Portrait of a Young Lady*, in the Royal Academy Exhibition that opened at the beginning of May 1795.

But just a week before that date, tragedy struck. Pinkie died on April 23, 1795. She was buried on April 30 at St. Alfege's, Greenwich, on the eve of the opening of the exhibition. We do not know what caused her death, but her grandmother's rather ominous reference to a cough in one of the letters to Mrs. Williams suggests that Pinkie, like so many of her contemporaries, may have been a victim of tuberculosis. It is a sad irony that the first public appearance of the portrait must have taken on (at least in the minds of the sitter's family and the artist) the character of a memorial occasion.

❧ History of the Painting

❧ Curiously enough, in view of the great popularity of the painting today, *Pinkie* seems to have passed virtually unnoticed at the exhibition of 1795. In fact, Lawrence generally received scant attention from the critics that year. His competitors, Hoppner, Beechey, and Northcote, ran off with most of the acclaim. Hoppner in particular seems to have been the most favored artist of the moment. He was chosen to paint the portrait of the new Princess of Wales, a suggestion defended by *The Times* with the comment: "His merit is so undoubted that his brother artists cannot reasonably complain to the preference given to him."

After the Royal Academy Exhibition, Pinkie's portrait moved into the private collection of her family and was not again seen publicly for more than one hundred years. One basic detail in the subsequent history of the painting is unfortunately obscure. We do not know whether in fact it ever made the journey across the Atlantic to Jamaica. A letter of October 12, 1795, to Mrs. Williams from her sister in Jamaica states, "poor Pinky's picture has never been heard of—Hibberts says it never was sent to his house he knows nothing of it." But this uncertainty aside, by the middle of the first decade of the nineteenth century

the portrait was in London in the possession of Pinkie's brother Edward, the father of the poet Elizabeth Barrett Browning. It remained with members of the Moulton-Barrett family (Pinkie's brother added the "Barrett" to his name in 1798) until the early years of this century. Its second public appearance, one hundred and twelve years after the first, was again at the Royal Academy, in the Old Masters Exhibition of 1907. The success it had there prompted a reappearance at an exhibition a year later at Agnew's. In 1910 the then-owner, Mrs. Maria Elizabeth Moulton-Barrett, parted with the painting by private sale to Lord Michelham. When Lord Michelham's collection was auctioned on November 24, 1926, the portrait was acquired by Duveen for 74,000 guineas, then considered to be the highest price ever paid for a painting at open auction. *Pinkie* passed into the Huntington collection less than two months later, in January of 1927. It was Mr. Huntington's last major painting purchase before his death on May 23, 1927.

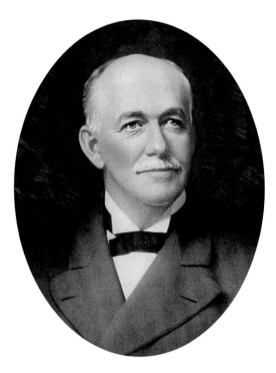

Plate XVI

Henry E. Huntington purchased *The Blue Boy* in 1921
and *Pinkie* in 1926.

❧ Sir Thomas Lawrence, 1769–1830

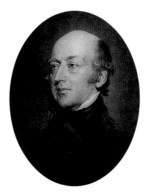

❧ Born the son of an innkeeper in the port town of Bristol, Lawrence gained early renown for his skill in making pencil portraits of elegant travelers at his father's coaching inn, The Black Bear, at Devizes. Apart from casual instruction, he was essentially self-taught. The boy's precocious talent for draftsmanship became a crucial source of income when his father was declared bankrupt in 1779. The family's move to Bath the following year provided Lawrence with a sophisticated clientele and the means of educating his taste. He assiduously copied Old Master pictures displayed in the city's print shops and private collections, and essayed his own Grand Manner subject pictures in imitation of them.

In the summer of 1787 Lawrence settled permanently in London. Initially specializing in pastel portraits, he turned almost exclusively to oil painting following a few months' study at the Royal Academy Schools. The glamorous and vivacious full-lengths he exhibited in the 1790s secured his preeminence among the younger generation of painters. Nevertheless, some critics complained of artificiality and carelessness in his work. In *Pinkie* and *Lady Jane Long* (1793), for example, Lawrence

distorted the length of his sitters' arms in order to achieve a desired artistic effect rather than anatomical accuracy.

Lawrence cultivated the friendship of rich and influential people and, to his peril, emulated their opulent habits. In the late 1790s and early 1800s, financial embarrassment and the demands created by his own success caused him to undertake an excessive number of commissions. Studio assistants became increasingly important to his practice, and it was they who completed the two hundred portraits that remained unfinished at the time of his death (among them, the Huntington's *Mrs. Cunliffe-Offley*). Despite some decline in the overall quality of his work, Lawrence's reputation remained high. Knighted in 1815, he went to Vienna in 1818 as envoy of the Prince Regent, with a prestigious commission to paint the victorious allies in the Napoleonic Wars. Following an instructive visit to Rome, Lawrence returned to England in March 1820. During his absence he had been elected President of the Royal Academy.

Lawrence's art changed with the times, and his later works reflect the nineteenth-century penchant for sentimentality. Comparison of the Huntington's portrait of Emily Anderson as *Little*

Red Riding Hood (about 1821) with *Pinkie*, painted a quarter-century earlier, betrays the mellowing of the artist's youthful crispness and vitality. The range charted by these works bears out the claim of his contemporary and rival, Benjamin Robert Haydon, that "Lawrence was suited to the age and the age to Lawrence."

<div align="right">Robyn Asleson</div>

Designed by Kathleen Thorne-Thomsen
in Mrs. Eaves with Benguiat Gothic heads
Printed on Perigord Matt by CS Graphics PTE LTD